WAYS
OF
DRAWING
Cats

DAY AFTER DAY,
NEVER FAIL TO DRAW SOMETHING
WHICH, HOWEVER LITTLE IT MAY BE,
WILL YET IN THE END BE MUCH,
AND DO THY BEST.

CENNINO CENNINI c.1390

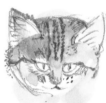

WAYS
OF
DRAWING

Cats

A guide to expanding your visual awareness

RUNNING PRESS
PHILADELPHIA, PENNSYLVANIA

WPK **MAY 2 1994**
743.5
W359

Produced, edited, and designed by Inklink,
Greenwich, London, England.

Canadian representatives: General Publishing Co., Ltd.,
30 Lesmill Road, Don Mills, Ontario M3B 2T6.
International representatives: Worldwide Media Services, Inc.,
30, Montgomery Street, Jersey City, New Jersey 07302.

9 8 7 6 5 4 3 2 1
Digit on the right indicates the number of this printing.

WAYS OF DRAWING CATS,
a guide to expanding
your visual awareness

Copyright © 1994 by Inklink

**This edition first published
in the United States by
Running Press Book
Publishers.**

Library of Congress
Catalog Number
93-085537

ISBN 1-56138-395-3

CONSULTANT ARTISTS AND EDITORIAL BOARD
Concept and general editor, Simon Jennings
Contributing artist, Richard Bell
Anatomical artist, Michael Woods
Natural history illustration advisor, John Norris Wood
Art education advisor, Carolynn Cooke
Design and art direction, Simon Jennings
Additional design work, Alan Marshall
Text editors, Ian Kearey and Albert Jackson
Historical research, Chris Perry

Typeset in Akzidenz Grotesque and Univers by Inklink
Image generation by T. D. Studios, London
Printed by South Sea International Press, Hong Kong

This book may be ordered by mail from the publisher.
Please add $2.50 for postage and handling.
But try your bookstore first!

Running Press Book Publishers
125 South Twenty-Second Street
Philadelphia, Pennsylvania 19103-4399

CONTENTS

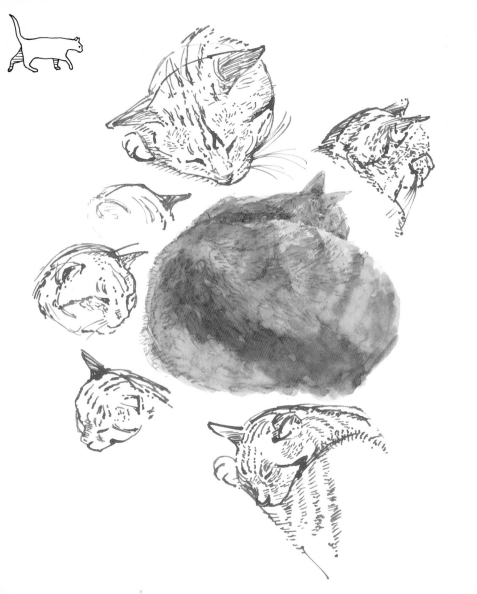

Introduction The familiar pet cat is the only semi-domesticated animal that we freely welcome into our homes. The tiger burning bright in the Asian forest and the cat dozing by your hearth are both members of the same large family, *Felidae*, and the domestic cat still retains its independence and fierce, predatory instincts.

Cats are particularly beautiful animals, with lithe and supple bodies, who cannot help posing elegantly, though they will not pose – or do anything – to order; to artists they offer an almost irresistible subject, but without help, the problems can appear to be daunting.

This book lets you into the secret. From the drawings of feline anatomy to sketchbook pages packed with lively and characterful studies, the visual art is supported by a well informed and witty text. The artist's affection for, and knowledge of his subject is clear on every page, and there are many suggestions for approaches to drawing and techniques – pencil, pen and ink, watercolor, and drybrush, among others.

Over the centuries, cats have appealed to artists and illustrators of widely diverse styles and approaches, and many examples of the resulting work are included in the "Index of Possibilities."

Fired by this information and reinforced by the confidence it inspires, you will find it difficult to resist the urge to try for yourself. You will be astonished by how much you improve, and regular practice with this friendly guide will lead to much pleasure and excitement – perhaps even, one day, to perfection!

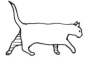

Understanding a cat's anatomy Cats hold a fascination for artists, due in part to the cat's legendary agility and flexibility, that almost amount to double-jointedness. However, these same qualities that make cats such attractive subjects for sketching and drawing also make them very frustrating to portray accurately!

Even a rudimentary understanding of the relationship between the skeleton and muscles that lie beneath that blanket of fur will help you draw the various aspects of cat anatomy that seem so troublesome to artists, such as the back legs, feet, and face. And whether you are drawing domestic cats at home, or big cats in a zoo or wildlife park, they all share the same physical characteristics unique to the cat family, and familiarity with these characteristics will pay dividends.

Working from stuffed specimens in a museum can never be completely satisfactory without at least a working knowledge of anatomy; and although they may be useful ways of building up a visual reference library, even the best and most detailed photographs can never quite convey the cat's loping, easy, fluid walk.

To get successful results, you need to make drawings based on first-hand observation. Stalking cats, for example, appear to be all shoulder blades, spine, and hipbones, so it is worth knowing what these look like and how they work before you attempt to suggest them in your drawings. Even a curled-up, sleeping cat will look more convincing on paper if you are aware of the various directions of fur growth, and how the muscles are arranged under the skin.

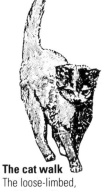

The cat walk
The loose-limbed, ambling walk, common to all members of the flexible cat family, is characterized by a rise and fall of the shoulder blades and covering flesh.

Skull
The characteristic, round, flat face of the cat is formed by large, protruding cheekbones, forward-facing eye sockets, and a short muzzle — the muzzles of most dogs are three times as long.

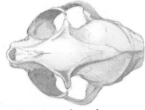

Top view of cranium

The two most important features that distinguish a cat from other long-tailed, carnivorous quadrupeds are the shape of the skull and that of the feet.

Claws extended

Claws retracted

Paws
Depending on the position of the the crooked toes, paws can be aggressive-looking or soft and harmless. When the ligament beneath the paw is tensed, the toes and claws extend, the knuckles become more prominent, and the whole of the foot becomes flatter.

Front legs
A cat's front legs are usually more sturdily built than the back legs; this difference is most noticeable in leopards and tigers.

Dewclaw
A real toe, the dewclaw corresponds to the thumb.

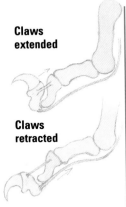

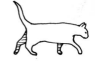

Shoulder blades
When a cat crouches close to the ground while stalking its prey, the shoulder blades become especially prominent.

Tail
The caudal appendage is one of the cat's most expressive features, whether held erect in contentment or bristling in anger.

Knee

Hind legs
These powerful limbs enable the cat to make impressive leaps from a standing position. They are usually partly obscured by fur.

Soft, rounded pads
The underside of the paw is cushioned by these pads.

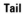

Foot

Felis catus

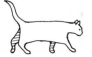

Muscle development is most prominent under the short fur of big cats, and combines with folds of skin to create the athletic form of the animal.

Shoulder
The curved shoulder is a typical feature of the poses adopted by cats at play.

Hindquarters
Note the powerful hind-quarters of the feline species. The muscular construction enables the animal to perform massive leaps.

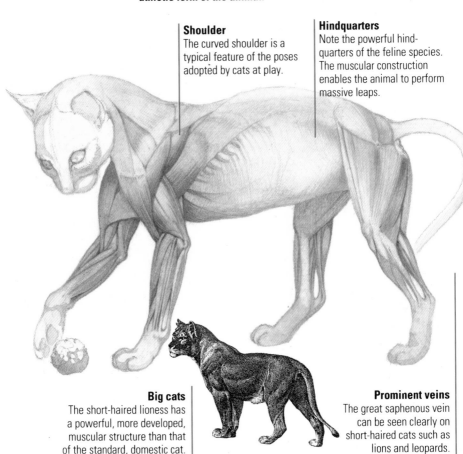

Big cats
The short-haired lioness has a powerful, more developed, muscular structure than that of the standard, domestic cat.

Prominent veins
The great saphenous vein can be seen clearly on short-haired cats such as lions and leopards.

The growth patterns of feline facial hair are well-defined; the direction of growth of chest and leg hair is more complex (see below). Note also the characteristic details of the feline eyes, nose, and ears.

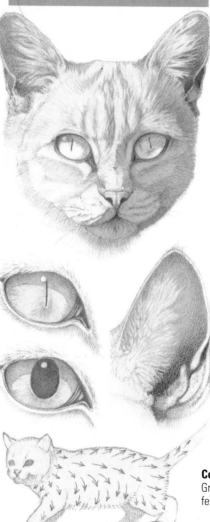

Forehead fur
This is grouped in well-defined ridges, that coincide with the facial markings on tabby cats and the big spotted cats. These ridges actually cast shadows, but they are only clearly visible on self-colored cats.

Eyelids
Cats' eyelids cast shadows. The eyelid rims and the corners of the eyes are black, though this varies from cat to cat.

Pupils
The pupils change shape and size according to available light. The tone of the iris is not even, and is also affected by light.

Eyebrow hair
This hair is often longer than that on the rest of the face, and may grow in a different direction.

Nose
The feline nose is distinguished by its overall shape, grooves, nostrils, and other markings.

Whiskers
These stiff, sensitive hairs grow out of grooves among the ordinary muzzle hair.

Ears
Cats have fascinating ears with velvet-like hair on the outside and smooth skin on the inner surface. Note the intricate fold where the ear joins the head.

Covering
Growth pattern of feline body hair.

Natural history illustration is generally dismissed by art historians as a backwater, separate from the mainstream of western art. Landscape painting was once dismissed, in a similar offhand way, as mere topographical representation. But, to judge by the earliest surviving paintings and drawings, there is a deep compulsion within us to make representations of the animals we see around us; this is particularly so with domestic cats.

The earliest cave paintings are said to embody sympathetic magic, and it does seem that they must have had some extraordinary significance; why else would some have been made in such inaccessible places as deep, underground caves? But it is also likely that the artists who made the drawings

greatly enjoyed their work. Their first-hand observation of the animals comes over in the confident handling of the drawings. Mythical icons, or little more than symbolic representations, they may be, but the cave animals are, above all, living, breathing animals.

There is still a vestige of natural magic in drawing. When you spend time quietly observing an animal – and cats are a good example – you often find that you begin to identify with your subject. To some extent, you can enter imaginatively into its world and begin to see the cat's point of view. It may seem surprising that so much of a cat's character can end up on the sketchbook page, even when the technique lags behind the artist's expectations; but it is also an incentive to keep on looking and drawing.

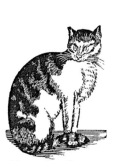

The real cat?
Old engravings and drawings, although full of minute details, often look stiff or romanticized, and certainly unreal. Today, artists seek to capture the essence of the living animal.

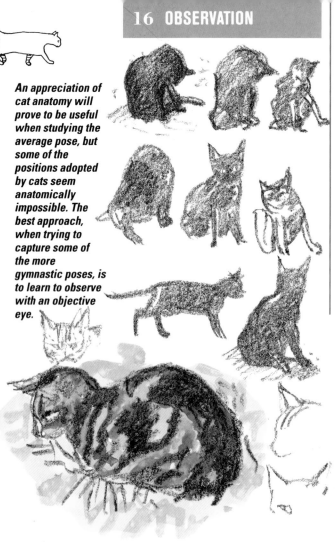

An appreciation of cat anatomy will prove to be useful when studying the average pose, but some of the positions adopted by cats seem anatomically impossible. The best approach, when trying to capture some of the more gymnastic poses, is to learn to observe with an objective eye.

Observation

Although a detailed knowledge of anatomy may be invaluable when reconstructing a pose for a studio painting, less inhibited, more lively results can be achieved by observing the animal at first hand, without becoming bogged down by theory. Japanese artists, for example, were said to spend a whole day watching their subjects before making drawings in a relatively short time.

"Look at the way the Japanese painted birds and fish. Their system was quite simple. They sat down in the countryside and watched birds flying. By watching them carefully they finally came to understand movement; and they did the same as regards fish."

From the notebook of Auguste Renoir (1841-1919)

Sketches versus finished work

The fascination of looking at any artist's sketchbook is that you can see the process of drawing in action. Leonardo da Vinci's sketchbooks, for example, are often far more interesting than his highly finished set pieces.

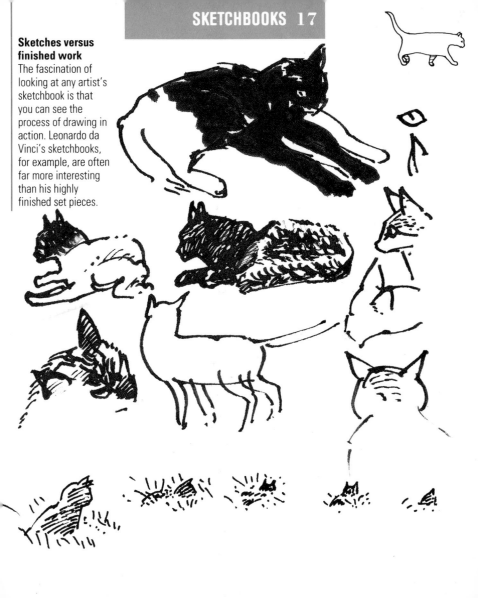

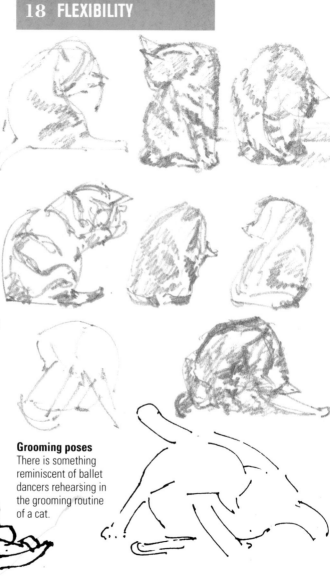

The cat's washing routine is a gymnastic workout. It can twist itself into a bewildering sequence of movements, with limbs sticking out in every direction.

Visual notes

Often, poses are held for a short time only; record them with a lightning sketch that is more of a visual note than a drawing. Observing the extraordinary range of movements will also help when you tackle more conventional poses.

Grooming poses

There is something reminiscent of ballet dancers rehearsing in the grooming routine of a cat.

Many people who have just taken up drawing attempt to erase their false starts – if you were to do this when drawing cats, you would sometimes spend more time erasing than drawing!

Continuous movement

This squatting, ready-for-action pose is typical, but difficult to capture; the cat continuously swivels its head, scanning its territory for sounds and movement. The drawing on the right shows an alternative position for the head: the pose changed when the cat's interest was suddenly drawn to the left. This false start has been retained as part of the record.

These drawings of a ginger-and-white tomcat on a doorstep are typical of the sort of visual shorthand you may have to resort to when sketching cats. A hurried note like this isn't ideal, but it is very much better than nothing at all.

On the alert

You can see that this cat was on the alert by the three pencilled positions for his right ear. The yellow-brown added to the pencil sketch records a slight change in the position of his tail. The gray of the step was added just after the cat moved off, to check out something in the yard. It was worth suggesting the step color, in order to emphasize the white areas of the coat.

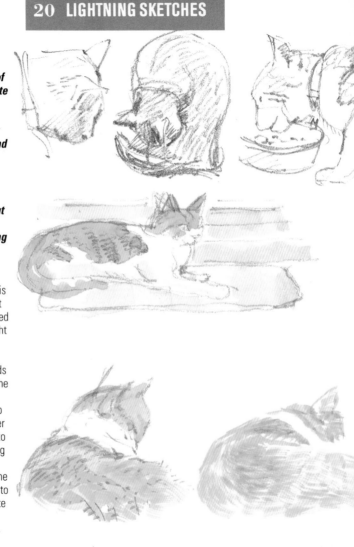

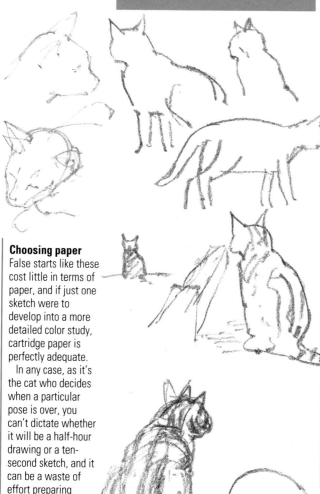

The sketches here illustrate the difficulty of drawing moving subjects. In these circumstances, it pays to use good-quality cartridge paper, rather than thicker, more expensive, water-color paper.

Rival gingers
In this little scenario, the artist wanted to show what the cat in the foreground was looking at so intently, so he included a second cat, drawn much smaller to indicate the distance between them. The perspective is not true-to-life; from where the artist was crouching, he could not have fitted both cats on the page, so, like a director of westerns, he zoomed into the action.

Choosing paper
False starts like these cost little in terms of paper, and if just one sketch were to develop into a more detailed color study, cartridge paper is perfectly adequate.

In any case, as it's the cat who decides when a particular pose is over, you can't dictate whether it will be a half-hour drawing or a ten-second sketch, and it can be a waste of effort preparing stretched watercolor paper beforehand.

A quick, perspective outline of a doorstep acts as a frame of reference for the cat's fore-shortened shape.

Conventional perspective

Artists from the cave painters and ancient Egyptians to the cubists managed perfectly well without conventional perspective, so it is not an essential ingredient in a work of art. However, attempting to make a foreshortened cat lie down convincingly in a drawing is an entertaining exercise.

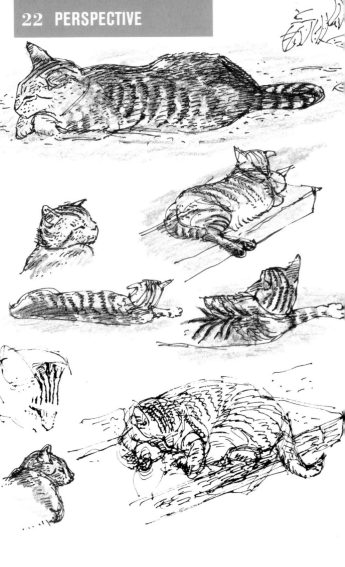

This cat always has a lopsided ear.

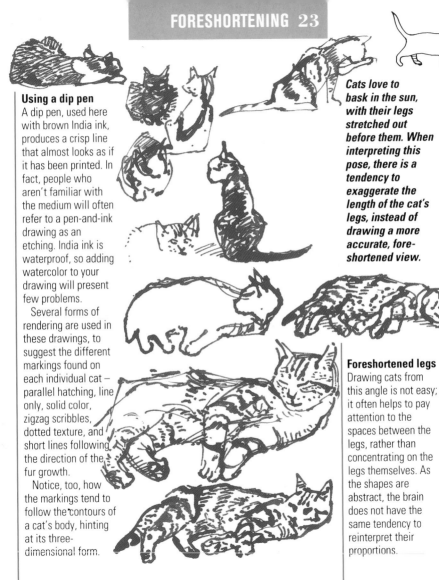

Using a dip pen

A dip pen, used here with brown India ink, produces a crisp line that almost looks as if it has been printed. In fact, people who aren't familiar with the medium will often refer to a pen-and-ink drawing as an etching. India ink is waterproof, so adding watercolor to your drawing will present few problems.

Several forms of rendering are used in these drawings, to suggest the different markings found on each individual cat – parallel hatching, line only, solid color, zigzag scribbles, dotted texture, and short lines following the direction of the fur growth.

Notice, too, how the markings tend to follow the contours of a cat's body, hinting at its three-dimensional form.

Cats love to bask in the sun, with their legs stretched out before them. When interpreting this pose, there is a tendency to exaggerate the length of the cat's legs, instead of drawing a more accurate, fore-shortened view.

Foreshortened legs

Drawing cats from this angle is not easy; it often helps to pay attention to the spaces between the legs, rather than concentrating on the legs themselves. As the shapes are abstract, the brain does not have the same tendency to reinterpret their proportions.

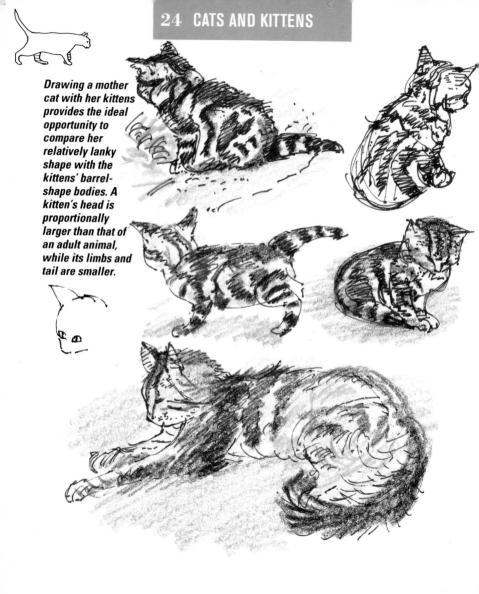

Drawing a mother cat with her kittens provides the ideal opportunity to compare her relatively lanky shape with the kittens' barrel-shape bodies. A kitten's head is proportionally larger than that of an adult animal, while its limbs and tail are smaller.

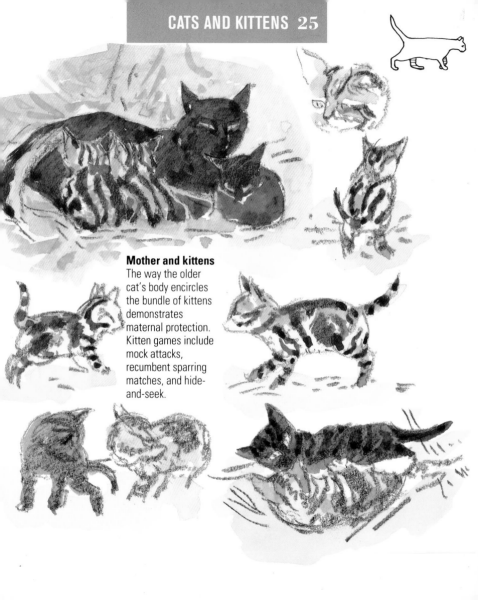

Mother and kittens
The way the older cat's body encircles the bundle of kittens demonstrates maternal protection. Kitten games include mock attacks, recumbent sparring matches, and hide-and-seek.

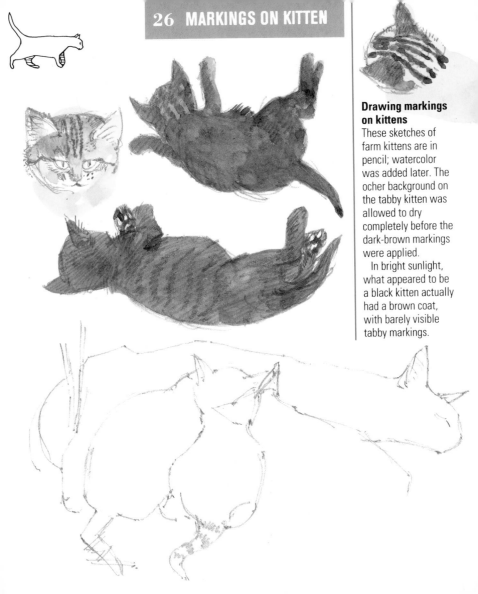

Drawing markings on kittens

These sketches of farm kittens are in pencil; watercolor was added later. The ocher background on the tabby kitten was allowed to dry completely before the dark-brown markings were applied.

In bright sunlight, what appeared to be a black kitten actually had a brown coat, with barely visible tabby markings.

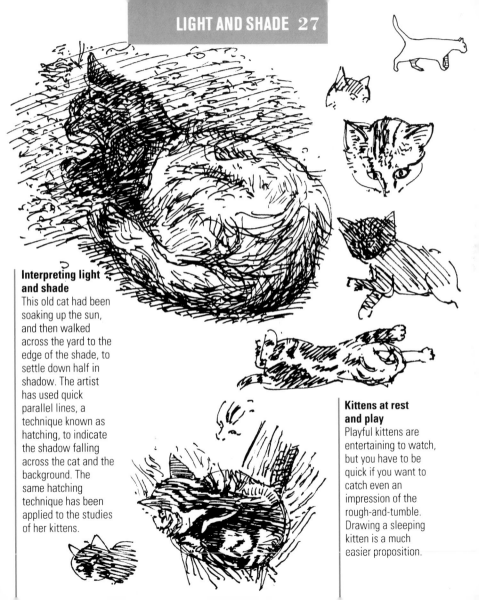

Interpreting light and shade

This old cat had been soaking up the sun, and then walked across the yard to the edge of the shade, to settle down half in shadow. The artist has used quick parallel lines, a technique known as hatching, to indicate the shadow falling across the cat and the background. The same hatching technique has been applied to the studies of her kittens.

Kittens at rest and play

Playful kittens are entertaining to watch, but you have to be quick if you want to catch even an impression of the rough-and-tumble. Drawing a sleeping kitten is a much easier proposition.

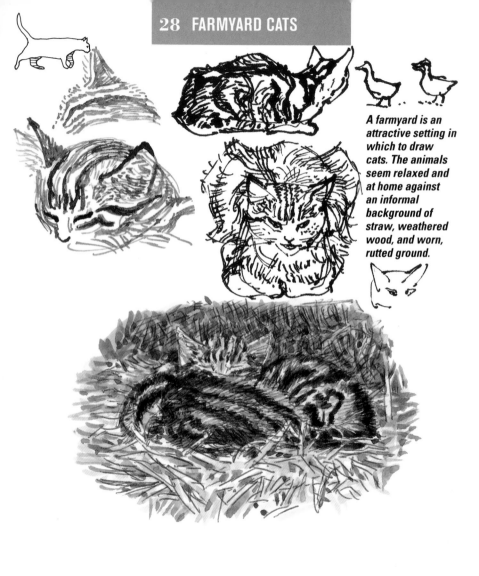

A farmyard is an attractive setting in which to draw cats. The animals seem relaxed and at home against an informal background of straw, weathered wood, and worn, rutted ground.

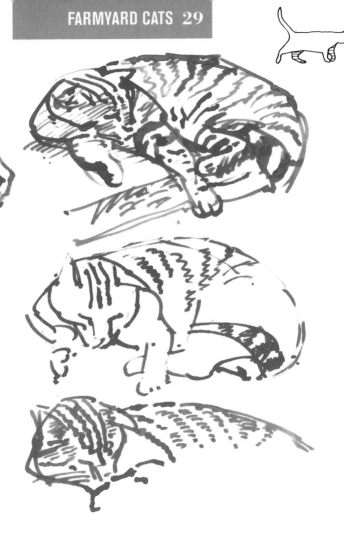

Quill-pen sketches
These drawings
demonstrate the
variety of marks
obtainable with a
quill pen. The nib
makes broad
downstrokes, while a
sideways movement
of the quill produces
a fine line. The
studies of mother cat
and kittens were
drawn with thick
outlines; rapid,
oblique hatching built
up the shading.

Indicate the firm
backbone and
shoulders of a kitten
with a continuous
line; broken line and
hatching will suggest
its soft underbelly

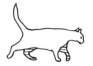

You can work outside without getting under the farmer's feet. When sketching in someone's home, you are always aware of being in the way.

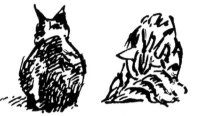

Working with calligraphy ink

These sketches were drawn with a quill pen, using calligraphy ink. This ink produces a dense black and flows easily, but, unlike the more viscous India ink, it is not waterproof when dry. You can't, therefore, use it as a basis for a watercolor drawing or wash.

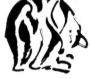

A surfeit of models

In a one-cat house-hold, you are at the mercy of the animal: if it decides to wander off, there is nothing you can do about it. One big advantage of working in a farmyard is the larger feline population: as soon as one cat moves away, there is another to turn to.

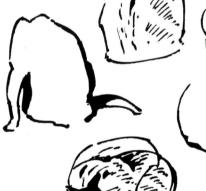

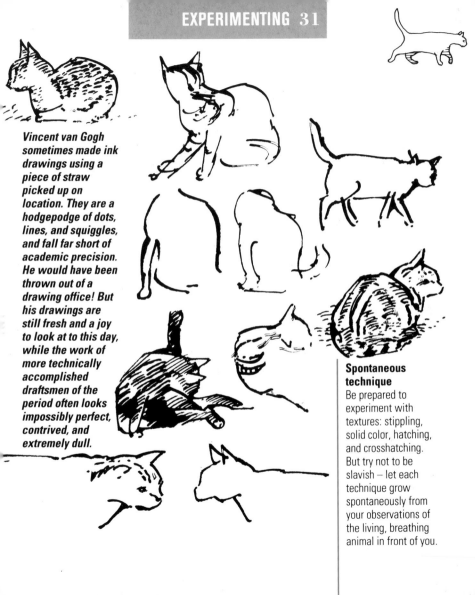

Vincent van Gogh sometimes made ink drawings using a piece of straw picked up on location. They are a hodgepodge of dots, lines, and squiggles, and fall far short of academic precision. He would have been thrown out of a drawing office! But his drawings are still fresh and a joy to look at to this day, while the work of more technically accomplished draftsmen of the period often looks impossibly perfect, contrived, and extremely dull.

Spontaneous technique

Be prepared to experiment with textures: stippling, solid color, hatching, and crosshatching. But try not to be slavish – let each technique grow spontaneously from your observations of the living, breathing animal in front of you.

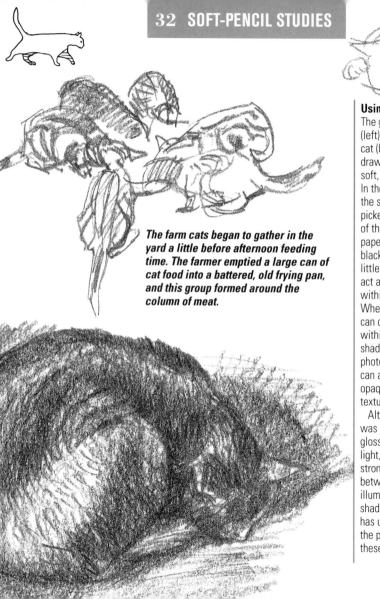

Using soft pencil
The group of cats (left) and the black cat (below) were drawn with a very soft, EE grade pencil. In the lower drawing, the soft pencil has picked up the texture of the cartridge paper, even in the blackest areas, where little pits in the paper act as white stipple within the shadows. When drawing, we can detect detail within the darkest shadows, but in a photograph, shadows can appear harsh and opaque, and the texture is often lost.

Although the cat was jet-black, its glossy coat reflected light, creating a strong contrast between the illuminated areas and shadow. The artist has used the white of the paper to suggest these glossy areas.

The farm cats began to gather in the yard a little before afternoon feeding time. The farmer emptied a large can of cat food into a battered, old frying pan, and this group formed around the column of meat.

Just because a cat is battle-scarred and gangling, with a faded, weathered coat, does not make it less appealing as a subject. These old warriors are such strong characters that drawing them is a pleasure.

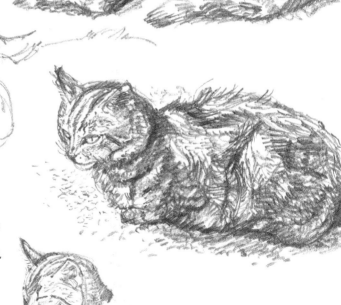

Capturing character

With these pencil studies, the artist has managed to convey the old tomcat's surly, almost arrogant, expression, and his shabby coat.

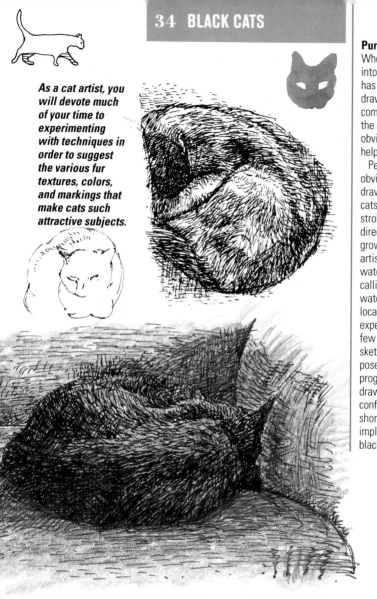

As a cat artist, you will devote much of your time to experimenting with techniques in order to suggest the various fur textures, colors, and markings that make cats such attractive subjects.

Pure black cats

When a cat rolls itself into a ball, the artist has very little left to draw. The problem is compounded when the cat has no obvious markings to help define the shape.

Pen and ink is an obvious medium for drawing pure black cats, using the pen-strokes to suggest the direction of fur growth. Here, the artist has opted for water-soluble calligraphy ink, plus watercolor pencils for local color. After experimenting with a few quick outline sketches to define the pose, you can progress to a finished drawing with confidence, using short penstrokes to imply the texture of black fur.

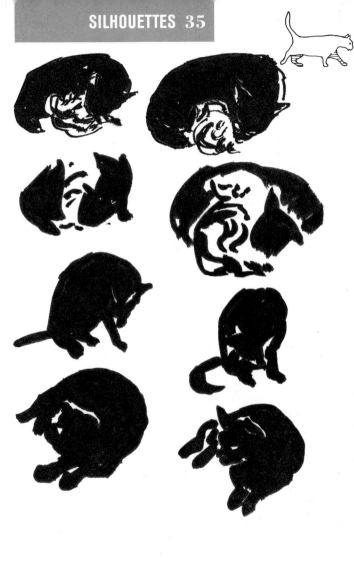

An alternative to painstaking pen-and-ink studies is to use a brush, to paint a black cat as a series of descriptive silhouettes.

Brush drawing

A medium-size sable brush produces a mark of the right thickness to describe a tail or limb with one brushstroke.

Brush and calligraphy ink impose a refreshing immediacy on your drawings, and you will quickly develop the knack of making each brushstroke count. However, it is also very easy to get carried away with the technique and start producing pleasing images, rather than truthful observations.

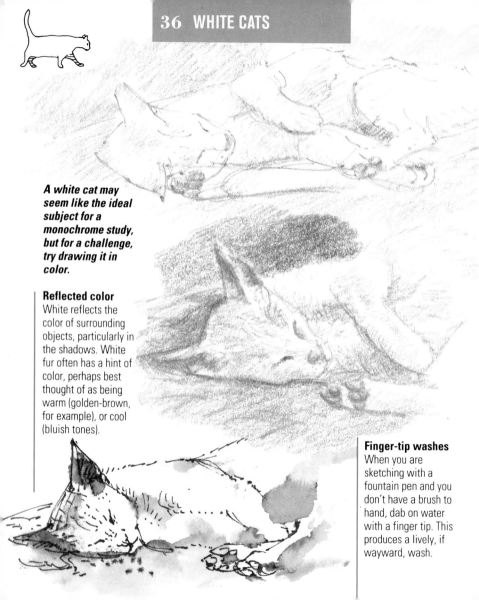

A white cat may seem like the ideal subject for a monochrome study, but for a challenge, try drawing it in color.

Reflected color
White reflects the color of surrounding objects, particularly in the shadows. White fur often has a hint of color, perhaps best thought of as being warm (golden-brown, for example), or cool (bluish tones).

Finger-tip washes
When you are sketching with a fountain pen and you don't have a brush to hand, dab on water with a finger tip. This produces a lively, if wayward, wash.

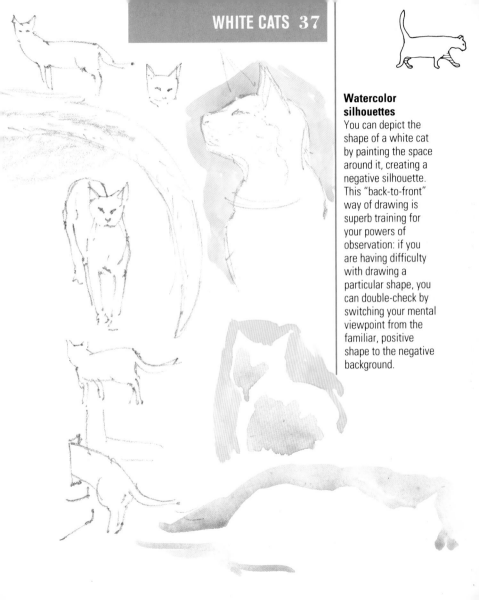

Watercolor silhouettes

You can depict the shape of a white cat by painting the space around it, creating a negative silhouette. This "back-to-front" way of drawing is superb training for your powers of observation: if you are having difficulty with drawing a particular shape, you can double-check by switching your mental viewpoint from the familiar, positive shape to the negative background.

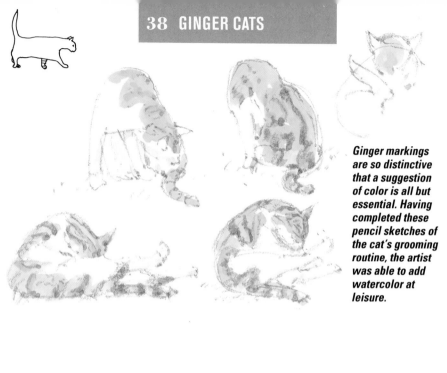

Ginger markings are so distinctive that a suggestion of color is all but essential. Having completed these pencil sketches of the cat's grooming routine, the artist was able to add watercolor at leisure.

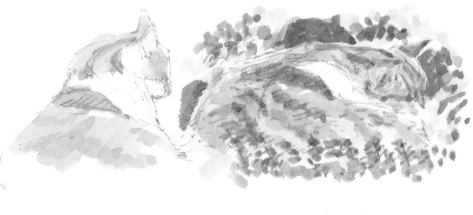

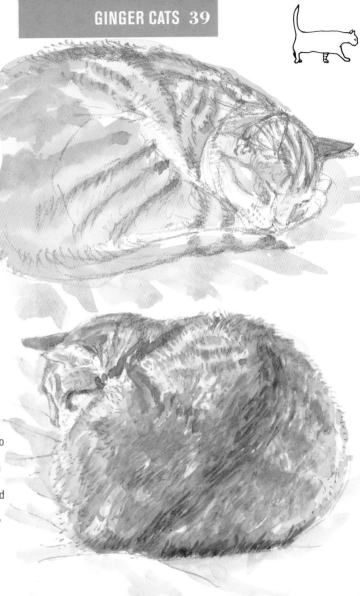

Overworking a drawing is hardly ever an improvement. Knowing when to stop is one of the most difficult lessons to learn. There are no hard-and-fast rules; it's something you have to learn by experience.

Studies and finished work

On the right-hand page, the drawings have been left at the initial, wash stage. Parts of these drawings could have been worked up still further, but the watercolor markings have been left deliberately vague.

The back view of the same cat (left) seemed to merit additional detail. Two or three applications of watercolor, on top of the initial pencil work, have been used to modulate the darker areas, as they comprise the main part of the study.

It can be amusing to draw your cat's portrait, if you can get it to sit still long enough.

Tabby faces
Watercolor was added to drawings made with soft-grade pencil that was dark enough to show through the overlaid washes.

Lilac Burmese
The subtle coloring of this Burmese cat varies, according to whether it is seen in natural or artificial light. As the name of the breed implies, its coat is not plain gray. To suggest this coloring, the artist lightly shaded the drawings with blue, ocher, and gray watercolor pencils.

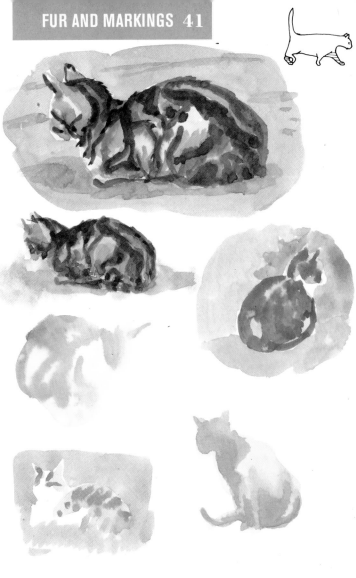

Sometimes, a cat's markings form complex patterns and assume misty gradations from one area of color to another, that may seem impossible to capture on paper.

Wet-in-wet watercolor

The wet-in-wet technique has an unpredictable, organic quality, evocative of tabby or tortoiseshell patterns.

First, paint the lightest background color of the cat; add the darker patches before this dries. The colors will run together, suggesting, but not reproducing exactly, the random markings on the cat. The skill is to let the medium work for you, rather than trying to force the paint into a particular shape. The result should look spontaneous.

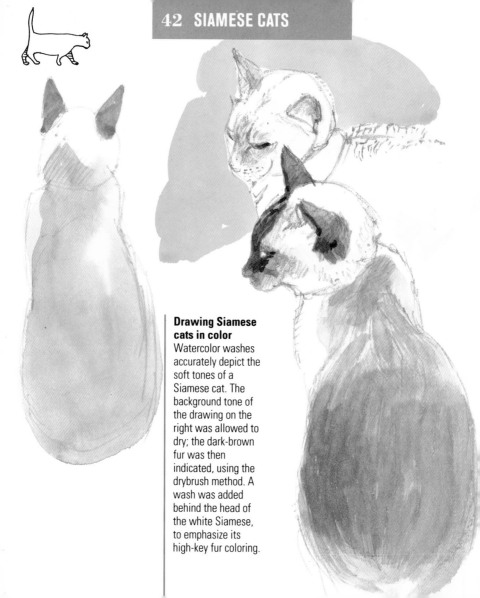

Drawing Siamese cats in color
Watercolor washes accurately depict the soft tones of a Siamese cat. The background tone of the drawing on the right was allowed to dry; the dark-brown fur was then indicated, using the drybrush method. A wash was added behind the head of the white Siamese, to emphasize its high-key fur coloring.

Siamese faces

Pen and ink is a decisive medium: there is no chance of erasing. Crisp, quick lines are one answer to the problem of drawing a continually moving subject. This Siamese was a very restless and uncooperative model. Drawing such a subject isn't relaxing; it is frustrating being unable to get what you see down on paper. It is, however, a good way to improve the reflexes between your hand and eye, and to improve your concentration.

Tabby Sealpoint Siamese

This incomplete drawing (right) was created piecemeal as the cat prowled around the room. In such circumstances, it is often best to stick to the simplest of mediums – 2B pencil with watercolor.

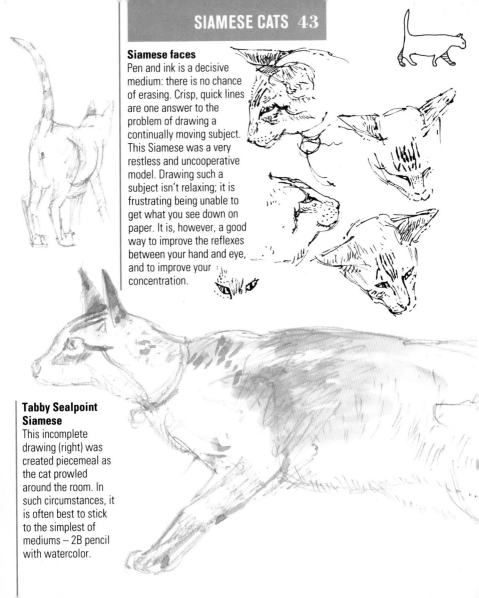

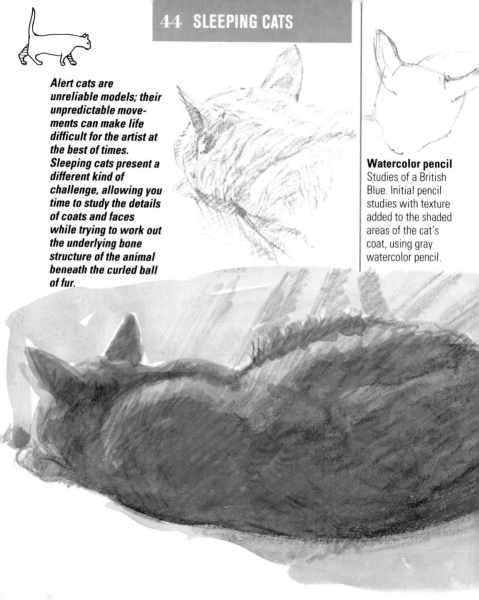

Alert cats are unreliable models; their unpredictable movements can make life difficult for the artist at the best of times. Sleeping cats present a different kind of challenge, allowing you time to study the details of coats and faces while trying to work out the underlying bone structure of the animal beneath the curled ball of fur.

Watercolor pencil
Studies of a British Blue. Initial pencil studies with texture added to the shaded areas of the cat's coat, using gray watercolor pencil.

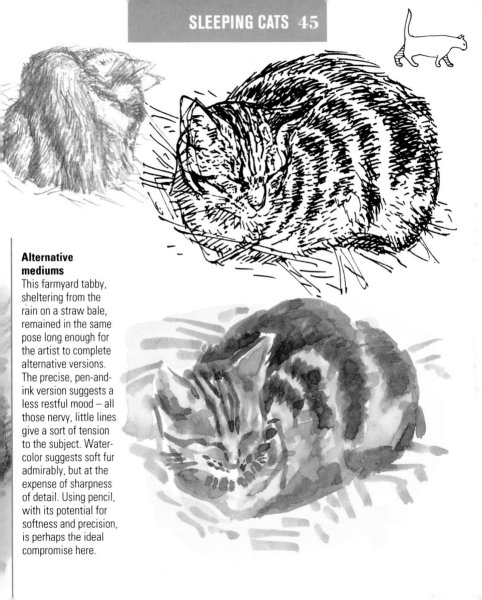

Alternative mediums

This farmyard tabby, sheltering from the rain on a straw bale, remained in the same pose long enough for the artist to complete alternative versions. The precise, pen-and-ink version suggests a less restful mood – all those nervy, little lines give a sort of tension to the subject. Watercolor suggests soft fur admirably, but at the expense of sharpness of detail. Using pencil, with its potential for softness and precision, is perhaps the ideal compromise here.

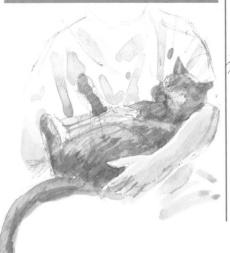

Getting friends to pose with their pets provides you with unusual opportunities for drawing cats. Often, the animal becomes totally relaxed – a gift to an artist used to the frustrations of chasing willful subjects. At other times, you get the chance to make amusing sketches as the animal struggles free.

Unwelcome attention

This watercolor was made in haste, before the reluctant model managed to struggle free. It demonstrates that you can't get a cat to relax if it doesn't want to!

Connie with Yentil

This ginger tomcat settled when required to pose on a friend's lap. Watercolor was applied over a fairly detailed 2B pencil drawing. When the washes were dry, texture was added to the figure and cat, using colored pencils.

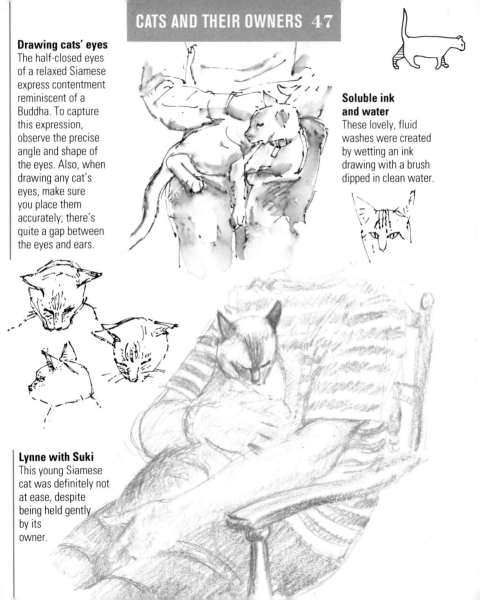

Drawing cats' eyes
The half-closed eyes of a relaxed Siamese express contentment reminiscent of a Buddha. To capture this expression, observe the precise angle and shape of the eyes. Also, when drawing any cat's eyes, make sure you place them accurately; there's quite a gap between the eyes and ears.

Soluble ink and water
These lovely, fluid washes were created by wetting an ink drawing with a brush dipped in clean water.

Lynne with Suki
This young Siamese cat was definitely not at ease, despite being held gently by its owner.

Watching real, live animals, even in the confines of a zoo, is a wonderful experience. Most visitors spend no more than five minutes watching each creature – when drawing, you have the opportunity for more prolonged observation.

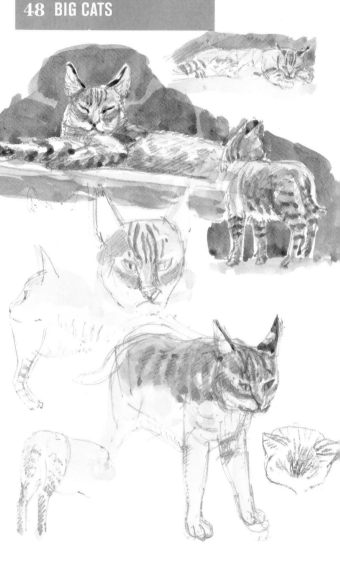

Jungle cat

Soon after the artist started drawing this resting jungle cat, she set off on a tour of her enclosure. The sketches of the active cat are compilations, put together detail by detail as she toured the cage. The sketch of the cat walking forwards is not one frozen moment, as a photograph would be, but is made up of perhaps twenty different poses.

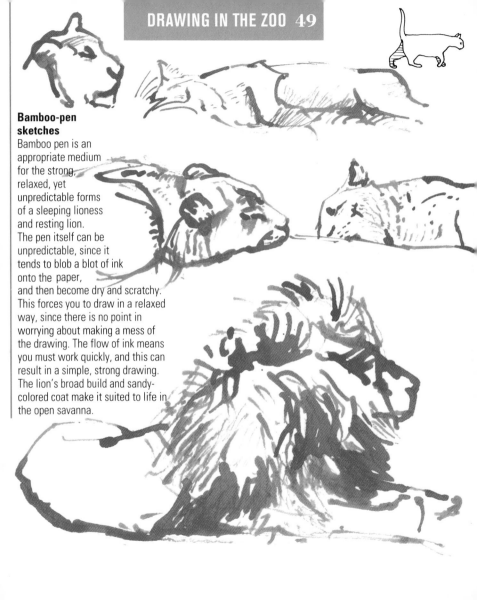

Bamboo-pen sketches

Bamboo pen is an appropriate medium for the strong, relaxed, yet unpredictable forms of a sleeping lioness and resting lion. The pen itself can be unpredictable, since it tends to blob a blot of ink onto the paper, and then become dry and scratchy. This forces you to draw in a relaxed way, since there is no point in worrying about making a mess of the drawing. The flow of ink means you must work quickly, and this can result in a simple, strong drawing. The lion's broad build and sandy-colored coat make it suited to life in the open savanna.

The fashion today is for more natural-looking enclosures in zoos. While this is still no substitute for conserving the animal in the wild, it does help to have an appropriate setting when drawing. The new, big-cat enclosures are certainly more suitable for the animals, who look at home among the rocks, logs, plants, and pools.

Tigers eating

Like many other predators, tigers like to bathe in a pond. As a background for a drawing, this semi-natural setting offers more of interest than bars on a cage. When these tigers had finished eating, they jumped into their pool for a cooling dip.

Proportions

The proportions of the tiger aren't those of a giant-sized domestic cat. The tiger appears to be flattened from side to side so that, compared to the lion, it has a lankier look. The tigers' stripes enable them to stalk prey unseen, through tall undergrowth in their forest habitat.

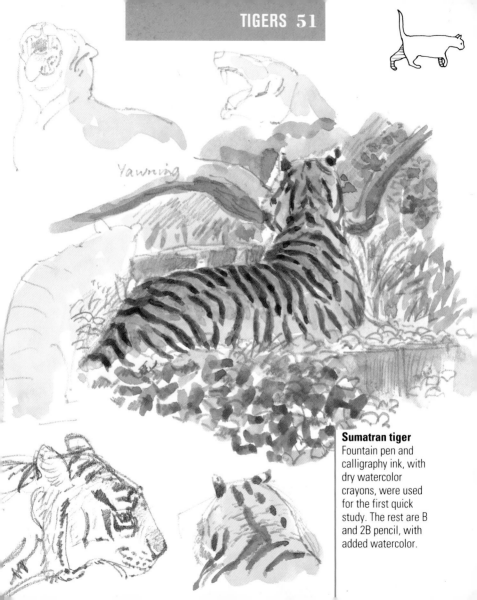

Yawning

Sumatran tiger
Fountain pen and calligraphy ink, with dry watercolor crayons, were used for the first quick study. The rest are B and 2B pencil, with added watercolor.

BASIC ESSENTIALS

The only essential equipment you need for drawing a cat is a pencil and a piece of paper. But, as your experience grows and your skills develop, you will hopefully discover your own drawing style. As this happens, you will probably develop a preference for using particular art materials. In this book you will have seen references to a variety of art terms, materials, and techniques, some of which may be new to you. The following is a glossary of useful information that relates to the artwork featured in this book.

MATERIALS

Graphite pencil
The common, "lead" pencil, available in a variety of qualities and price ranges. The graphite core (lead) is encased in wood and graded, from softness to hardness: 9B is very, very soft, and 9H is very, very hard. HB is the middle-grade, everyday, writing pencil. For freehand drawing work, start around the 2B mark.

Colored pencil
A generic term for all pencils with a colored core. There is an enormous variety of colors and qualities available. They also vary in softness and hardness, but this is seldom indicated on the packet.

Watercolor pencil
As above, except water-soluble and capable of creating a variety of "painterly" effects, by either wetting the tip of the pencil or working on dampened paper.

Conté crayon
Often known as conté pencil, and available in pencil or chalk-stick form. Originally a proprietary name that has become a generic term for a synthetic chalk-like medium, akin to a soft pastel or refined charcoal. It is available in black, red, brown, and white, but is best known in its red form.

Steel-nib (dip) pen
The old-fashioned, dip-in-the-inkwell pen. You will need to experiment with nibs for thickness and flexibility. They can take a while to break in and become free-flowing in use. However, the same nib can give a variety of line widths, as the artist changes the pressure on the pen.

Fountain pen
An ink pen that stores ink and releases it in an even flow. Changes of nibs are available; some fountain pens, but not all, can use waterproof inks.

Chinagraph
Trademark name for a waxy, waterproof, and versatile pencil.

Quill pen
Traditional writing and drawing pen, made from a goose feather.

Drawing ink
There are a variety of inks available, from water-soluble writing (fountain pen or calligraphy) inks to thick, permanent, and waterproof drawing inks. India ink is a traditional drawing ink; it is waterproof, very dense, and dries with an interesting, shiny surface when used thickly. Drawing inks are also available in a range of colors, and can be thinned down with water.

Paper
Varies enormously in type, quality, texture, manufacture, and price. Paper is graded from smooth to rough, and is either smooth (hot-pressed, or HP), medium (cold-pressed, or CP), or rough. The smoothness or roughness of a paper is known as the "tooth." The tooth of a paper will influence the way that a medium reacts to it.

TERMS

Drybrush
A drawing effect created by using a sparsely-loaded brush or dry, fiber-tip pen. Drybrush allows the texture of the paper or any drawing beneath to show through.

Mixed media
A drawing made using a combination of two or more materials, for example, graphite pencil used with watercolor pencil.

Line drawing
A drawing made up purely of lines, with no attempt to indicate shadow or darker areas through shading.

Shading
An indication of shadow or dark areas in a drawing, made by darkening the overall surface of the area, often by rubbing.

Tone
The prevailing shade in a drawing, and its comparative dullness or brightness.

Highlight
The lightest point in a drawing. This is often the point where light strikes an object, such as a reflection in an eye, or on a surface.

Hatching
An illusion of shadow, tone, or texture in a drawing, indicated by linework.

Crosshatching
An illusion of darker shadows, tones, or textures, indicated by

overlayering hatched lines at differing angles to each other.

Parallel hatching
Shadows, tones, or textures, indicated by drawing lines next to one another.

Scratching back
Removing the surface of a drawing with a sharp point, to reveal the paper, drawing, or color beneath.

Foreshortening
Producing an illusion of perspective on a single object by reducing the length of the lines of its long axis or axes.

Wet-in-wet
Applying a layer of watercolor paint over another, damp, one. The colors almost blend, creating hazy, unpredictable effects.

Stippling
Shading formed by dots or points, rather than lines.

POSSIBILITIES

INDEX OF POSSIBILITIES There are many ways of looking at the world, and there are as many ways of interpreting it. Art and creativity in drawing are not just about "correctness" or only working in a narrow, prescribed manner; they are about the infinite ways of seeing a three-dimensional object and setting it down.

In the earlier sections of this book, the consultant artist demonstrated the different approaches to drawing a specific subject. His examples show how he has developed a personal way of seeing and setting down cats on paper.

The following section of images is intended to further help you discover and develop your own creativity. It is an index of possibilities: an indication of just some of the inventive and inspirational directions that creative artists have taken,

and continue to take. This visual glossary demonstrates how the same subject can be treated in a variety of ways, and how different cultures and artistic conventions can affect treatments.

In every culture and age, symbols and simplified images are vital factors in communication. The earliest cave drawings reduce the forms of men and animals to the basics, and tell an immediate story; similarly, modern advertising campaigns and computer-based, corporate trademarks depend on our instant recognition of simplified forms. The graphic images in this section show how the artist's eye and hand can produce universally understood forms in all human societies.

A major part of artistic and technical development is being aware of, and open to, possibilities from outside your chosen sphere. To that end, the images in this section use a wide variety of materials and techniques. They may not all be pure "drawing," but each one expands the boundaries of what is possible, and provides new ways of seeing and interpreting cats.

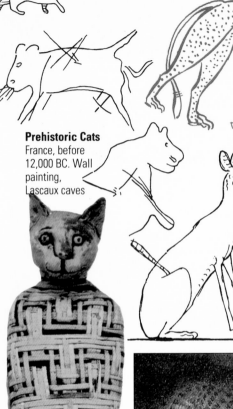

Prehistoric Cats
France, before 12,000 BC. Wall painting, Lascaux caves

Leopard Killing a Stag
Detail from a jug. Cycladic Islands, Greece, c. 700-650 BC. Clay

Seated Cat
Detail from the burial chamber of Tuthmosis III Egypt, c. 1490-1439 BC Wall painting

Cat under a Chair
Egypt, c. 1275 BC Wall painting

Hunting Cat
Italy, c. 100 BC Roman mosaic

Head of a Mummified Cat
Offering to the cat-goddess Bastet Egypt, after 30 BC

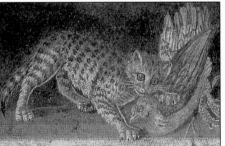

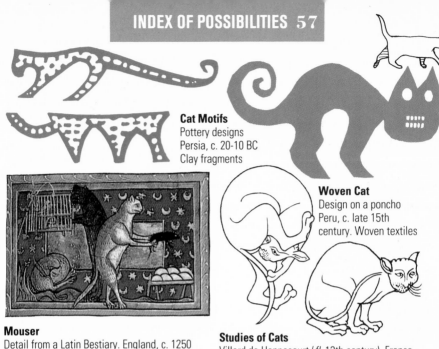

Cat Motifs
Pottery designs
Persia, c. 20-10 BC
Clay fragments

Woven Cat
Design on a poncho
Peru, c. late 15th
century. Woven textiles

Mouser
Detail from a Latin Bestiary. England, c. 1250
Illuminated manuscript

Studies of Cats
Villard de Honnecourt (*fl.* 13th century). France,
13th century. Illuminated manuscript

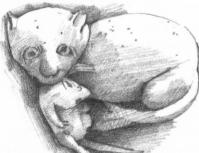

Studies of Cats
Leonardo da Vinci
(1452-1519). France,
1513-14 (below), 1517
(above). Pen and
ink (below), colored
chalk (above)

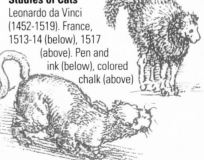

Cat and Mouse
Detail from a misericord in Winchester
Cathedral. England, c. 1308-10. Carved oak

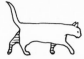

Study of a Cat
Thomas Gainsborough
(1717-88)
England, c. 1765
Charcoal and
chalk

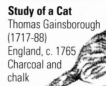

The Large Cat
Cornelis Visscher (1619-62). Holland,
17th century. Engraving

Black Cat
Detail from a
scroll. Chu Ling
(*fl.* 19th century)
China, c. 1800
Pen and ink

Cat Studies
Ando Hiroshige (1797-1858). Japan,
c. 1800. Woodcut

Studies of a Cat
Theodore Géricault
(1791-1824)
France, c. 1817
Pencil

Domestic Cat
Thomas Bewick (1753-1828). England,
1807. Wood engraving

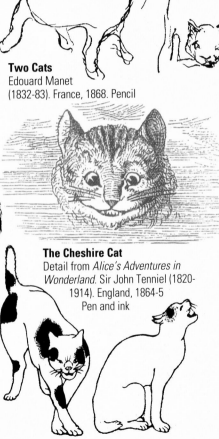

Two Cats
Edouard Manet
(1832-83). France, 1868. Pencil

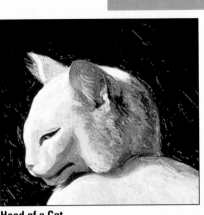

Head of a Cat
Detail from *White Cat*. Theodore Géricault
(1791-1824). France, early 19th century. Oil
on canvas

The Cheshire Cat
Detail from *Alice's Adventures in
Wonderland*. Sir John Tenniel (1820-
1914). England, 1864-5
Pen and ink

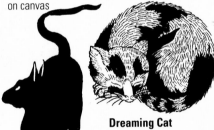

Dreaming Cat
Detail from *The Cat's
Dream*. Japan, 19th
century. Print

Black Cat
Detail from *Cats'
Rendezvous*. Edouard
Manet (1832-83)
France, 1868. Brush
drawing and wash

**Walking Cat and
Howling Cat**
Detail from *Fan Leaf
with Cats*. Utagawa
Kuniyoshi (1798-1861)
Japan, 19th century
Print

Pussycat
Detail from
a letter
Edward Lear
(1812-88)
England, 1871
Pen and ink

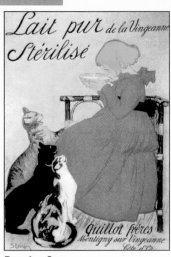

Lait pur de la Vingeanne
Stérilisé

Quillot frères
Montigny sur Vingeanne
Côte d'Or

Begging Cats
Detail from a dairy-product poster
Théodore Steinlen (1859-1923)
France, 1897. Lithograph

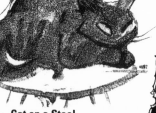

Cat on a Stool
Detail from *The Motograph*
Henri de Toulouse-Lautrec
(1864-1901). France, 1899
Blue crayon and India ink

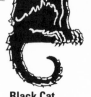

Black Cat
Detail from a cabaret
poster. Théodore
Steinlen (1859-1923)
France, c. 1895
Lithograph

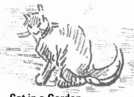

Cat in a Garden
Detail from *Garden with
Sunflowers*. Vincent van Gogh
(1853-90). France, July 1888
Pen and ink

The Black Cat
Detail from *Tales of
Edgar Allen Poe*
Aubrey Beardsley
(1872-98). England,
1895. Pen and ink

Cat Stalking a Mouse
Henri de Toulouse-Lautrec
(1864-1901). France, late 19th
century. Pencil

Study of a Cat
Sketch from the
artist's diary. Pierre
Bonnard (1867-1947)
France, December 29,
1931. Pen and ink

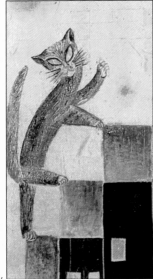

Cat Lying Down
Henri Gaudier-Brzeska (1891-1915)
England, c. 1913. Pen, brush, and
India ink

Cat on Rooftop
Detail from *Cats*. Otto Dix
(1891-1969). Germany,
1920. Oil on wood

Two Cats
Paul Klee (1879-1940)
Germany, 1915
Pen and ink

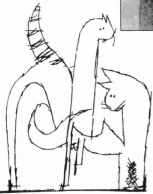

**The Cat Transformed
into a Woman**
Detail. Marc Chagall (1887-1985)
Paris, 1937. Oil on print

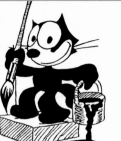

Felix the Cat
© Pat Sullivan
Pat Sullivan (1888-1933). USA, since 1919. Animated cartoons and comics

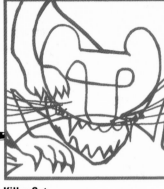

Killer Cat
Detail from *Tales of Aesop*
Alexander Calder (1898-1976)
USA, 1931. Monoline drawing

Seated Cats
China, 20th century. Paper cut (above). Russia, 20th century. Woodcut (below)

Kitten
Detail from *Monologue of a Kitten*. Paul Klee (1879-1940)
Switzerland, 1938
Pen and ink

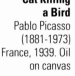

Cat Killing a Bird
Pablo Picasso (1881-1973)
France, 1939. Oil on canvas

Tom
© MGM. Bill
Hanna (b. 1911)
and Joe Barbera
(b. 1910). USA,
since 1939
Animated cartoons
and comics

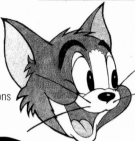

Sylvester
© Warner Brothers
Chuck Jones (b. 1914)
USA, since 1940s
Animated
cartoons and
comics

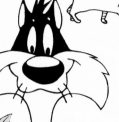

**Tubbs, Lewis
& Co. Logo**
Britain, 1928

Sam
Detail from *25 Cats
Name Sam and
One Blue Pussy*
Andy Warhol
(1930-87)
USA, 1954
Lithograph

**C. H. Leng
& Sons Logo**
Britain, 1932

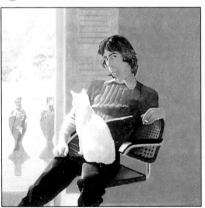

Cat with Erect Tail
Detail from jacket of novel *Poespas*
Czechoslovakia, 1950s. Woodcut

Percy on a Lap
Detail from *Mr. and Mrs. Clark and Percy*
David Hockney (b. 1937). England, 1970-1
Acrylic on canvas

CONTRIBUTORS AND CONSULTANTS

Contributing artist

Richard Bell first started drawing animals at the age of seven, and won a British national competition soon afterwards. He was the first student to graduate from the Natural History Illustration course at the Royal College of Art; since then, he has advised on natural history and worked on feature films, and has appeared on television programs about environmental education and location painting. He is the author and illustrator of two books, *Richard Bell's Britain* and *Down in the Wood*, and is the contributing artist to *Ways of Drawing Birds* in this series. He has exhibited at the Victoria and Albert Museum and the Natural History Museum in London.

Natural history illustration advisor

John Norris Wood is the founder and Head of the Natural History Illustration Department at the Royal College of Art in London. He is also a freelance wildlife artist, writer, and photographer, an expedition leader in America and Africa, and a keen and active conservationist.

SOURCES/BIBLIOGRAPHY

In addition to the original artwork shown in this book, many books, journals, printed sources, galleries, and collections have been consulted in the preparation of this work. The following will be found to make useful and pleasurable reading in connection with the history and development of the art of drawing cats:

Alice's Adventures in Wonderland,
L. Carroll, Wordsworth Editions, 1992
Animals in Art, A. Dent, Phaidon, 1976
An Atlas of Animal Anatomy for Artists,
W. Ellenberger, H. Dittrich, and H. Baum, Dover, 1956
Beardsley, D. Pearson, Courtier, 1966
British Trademarks of the 1920s and 1930s,
J. Mendenhall, Angus & Robertson, 1989
A Celebration of Cats, B. Caras, Robson, 1989
David Hockney by David Hockney,
Thames & Hudson, 1976
The Drawing Handbook, E. Maiotti, Aurum Press, 1989
Drawings from Ancient Egypt,
H. Peck, Thames & Hudson, 1978
The Encyclopedia of the Cat, A. Sayer, Octopus, 1979
The Encyclopedia of Comic Books,
R. Goulart, Time as Art, 1990
Favorite Cats, J. O'Neill, Gollancz, 1988
Leonardo da Vinci, South Bank Center, 1989
Masterpieces of Primitive Art,
D. Newton, Thames & Hudson, 1980
Otto Dix, E. Karcher, Benedikt Taschen, 1988
The Roots of Civilization,
A Marshack, Weidenfeld & Nicolson, 1972
Themes in Art: Cats, J. Nash, Scala, 1992
Toulouse-Lautrec,
P. Huisman and M. Dortu, Thames & Hudson, 1973
25 Cats Name Sam and One Blue Pussy,
A. Warhol, privately printed, 1954
Vincent van Gogh: Drawings, J. van der Wolk,
R. Pickvance, and E. Pey, Arnoldo Mondadori, 1990

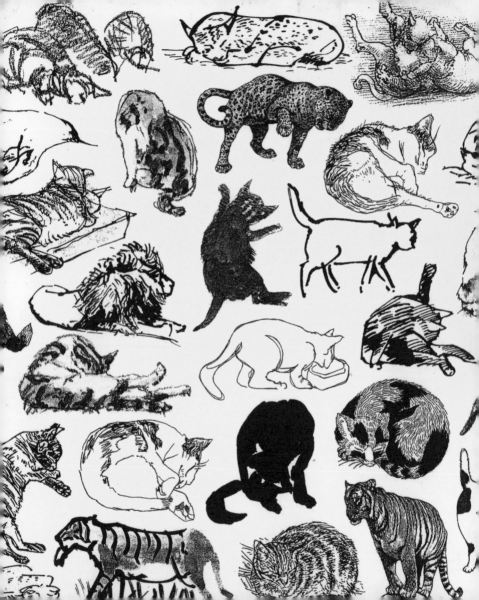